A Balthus Notebook

David Zwirner Books

*ekphrasis*

A Balthus Notebook
Guy Davenport

# Contents

# Editor's Note

Guy Davenport's *A Balthus Notebook* is reproduced here as it appeared in its first edition, published in 1989. In certain rare cases, however, we have made slight modifications to spellings and punctuation to reflect contemporary usage. Davenport's original citations have been converted to endnotes in the interest of greater readability. Dates for Balthus's works have been consistently applied, and existing date references have been moved to the endnotes; additionally, dates for works of art not by Balthus have been added where they were not originally noted. So that readers can further explore and gain insight from Davenport's text and sources, we have also included in the endnotes editorial commentary and expanded citations for select sections.

# Free Associations

Judith Thurman

Balthus, born Balthasar Klossowski, in 1908, was sixty-two when we met, fifty years ago. I had never known a great artist, and he looked the part, especially in paint-splattered trousers and a rakish ascot. His manners were lordly, and his languid speech caressed the French language even when he was bemoaning something, especially his work, which was always going badly, or modernity, with which he was at odds. He affected an air of tragic weariness, yet he still had the agile grace of the ephebe he had been, as well as a bad boy's appetite for surprise.

I was in my early twenties, fresh out of college, living abroad, and unformed in every sense. Physically, I could have passed for one of the adolescents in Balthus's paintings. If they were not naturally ungainly, he posed them in awkward positions, kneeling on the floor over a book, or asleep on a divan with their heads thrown back and limbs splayed in such a way as to guarantee a stiff neck and numb extremities upon waking. They tend to have poignant bodies rather than model ones: dense and round, with legs that seem even shorter in childish white anklets. Their imperfection renders them vulnerable, the more so as they aren't conscious of it. In one of his most famous pictures, *Nude in Front of a Mantel* (1955), a plump girl, with flesh of white marble, like the fireplace she stands at, is rooted to the floor by her flat feet (my feet exactly). She is represented in profile, gazing at a pier glass, so that she is, in effect, faceless, as the young

often are to themselves. She lifts her hair—a dark cascade—off her shoulders. It looks so heavy (my own hair weighed me down like a lead blanket) that her gesture seems to defy the gravity that her form conveys.

Balthus was, when we met, the director of the French Academy in Rome, which is housed in the sixteenth-century Villa Medici, on the Pincian Hill, above the Spanish Steps. He had overseen its restoration, and spent years trying to reproduce "Pieran blue," as he called it—the blue of Piero della Francesca's frescoes—for the walls. His chatelaine and second wife, Setsuko, née Ideta, was a woman of nubile charm, thirty-five years his junior, whom he had met on a cultural mission to Japan, where she had served as his group's interpreter. Setsuko exuded delicacy. She always dressed in a kimono (Balthus wore them himself from time to time), and she glided through the halls of the palazzo with birdlike steps.

I would never have been asked to the villa on my own account—I was of no account. But my boyfriend at the time was the son of distinguished figures in the French art world, and the four of us had been invited as a family. Our host spent most of the day in his atelier, and we met for meals. The spectral butler who served them wore white gloves, and called his master "*Signor Conte*." (Balthus styled himself "Le Comte de Rola," an invented title that he insisted upon even in the face of bohemian derision. He also claimed descent from Byron, the kings of Poland, and the Romanovs. But his father, Erich Klossowski, was a Polish émigré of genteel descent who lost

what fortune he possessed in the Second World War, and Balthus's mother, Baladine, née Elisabeth Spiro, was the daughter of a cantor from Breslau, though her son always denied he had Jewish blood.) From the beginning, the great man addressed me familiarly, as one would a small child, and I took his *tu* as a mark of affectionate condescension. I always said *vous* to him—on the rare occasions when I dared to speak. "Your little Judith is quite pretty, but isn't she a bit stupid?" he asked my boyfriend's mother. She knew that I would treasure the remark.

*Nude in Front of a Mantel* was posed against a wall of Pieran blue. I also posed against such a wall—though not for Balthus. Setsuko had begun to paint (years would pass before she showed her work), and she asked me to sit for her. A baroque armchair covered in its original fraying damask was pulled up to a window that overlooked the villa's gardens, which had once belonged to Lucullus, and I stared at the venerable umbrella pines until lunchtime, when Balthus joined us at an antique table that gave off a scent of beeswax. I made an effort to eat as Setsuko did, taking dainty bites. I cannot remember the conversation, though I was struck by my hosts' demeanor as a couple. They performed their roles with a courtly, even ritualized, politesse beneath which hummed a sensual understanding. You would never have known they were mourning a child, their two-year-old son, Fumio, who had died that year of Tay-Sachs disease.

Balthus was avian in physique though feline in temperament, and his totem animal was the cat. He had

made his artistic debut, at the age of thirteen, with a series of forty drawings, in pen and ink, that told the story of an Angora stray he had adopted. When the cat ran away, Balthus was heartbroken, and he turned to art for consolation. Rainer Maria Rilke, a family friend (he was having an affair with the tempestuous Baladine), was so impressed by the boy's gifts that he arranged for the drawings to be published as a little book, *Mitsou* (the defector's name, but also the title, not incidentally, of a novella by Colette, published that year), and supplied a preface.

Cats often figure in Balthus's dreamlike streetscapes, and as the house pets—or tutelary spirits—of the girls in his portraits. You cannot read the mind of a cat, and you have no idea what the girls are thinking, though their opaque reveries, you might suspect, resemble those of the eight-year-old provocateur whom Colette evokes in *My Apprenticeships*, a child who "already knew too much ... of the various terrible ways of giving oneself pleasure." The beauty of Balthus's work is unsettling morally and visually, and the Italian title of Elena Ferrante's first novel, *L'amore molesto*, seems apt for it. Balthus himself described the style of these portraits with the untroubled phrase "timeless realism." Both timelessness and realism have long been out of fashion, and were still so when Balthus embarked on his adult career. His first show, in Paris, in 1934, outraged critics both for its content—the precocious eroticism of pubescent subjects posed voyeuristically—and its technical "crudity." The artist of twenty-six became so depressed by this fail-

ure, which coincided with a lover's rejection, that he attempted suicide and stopped painting for a while. He also waited more than a decade to show his paintings in Paris again.

The charge of crudity is now hard to fathom. Few artists of the past century were more painterly than Balthus, whose masters were Courbet and della Francesca, and who worked so slowly, and with such tortured perfectionism, that he sometimes produced only two or three pictures a year. You can stare for a long time at the shadows on a wall in one of his interiors, rapt at their depth of nuance. Perhaps "crudity" was a Freudian slip on the part of a writer who meant to say "cruelty." There is a subtext of violation to the portraits (overt in a few of them), and the viewer is made complicit with it. Here one should note that none of the models or their chaperones ever accused Balthus of impropriety, and he indignantly defended his work against the charges that were leveled at it and at him. "Balthus has the immediacy of a naive painter," Guy Davenport writes, and one can best understand that naiveté not as a primitive state of mind but as an Edenic one—a trance of solitude insulated from any sense of wrongdoing. If one cannot quite understand it that way in 2020, we owe it to the art to examine the nuances of our discomfort. That is where Balthus's genius lies.

*A Balthus Notebook* was published thirty years ago, which is to say, a generation, yet an eon by the measure of social changes. As the critic Michael Dirda put it, Guy Davenport possessed "a sensibility appealingly out of step with our debased times." Few critics brought the depth of erudition to their work that Davenport did; fewer, if any, were his peers as a stylist. "Shoddiness demoralizes," he wrote succinctly. "Unless the work of art has wholly exhausted its maker's attention, it fails."

It is clear from the first lines of these lapidary aperçus that Davenport is addressing a reader undaunted by his references (the original edition had no footnotes). He free-associates symphonically in a scholarly language like Sanskrit or Mandarin. (The word "Mandarin", interestingly, may come from the Sanskrit *mantri*, referring to a councillor.) His own tastes, though, were refreshingly catholic. Davenport could write his name in Linear B, but he loved crime fiction and hillbilly slang. Tolkien was his tutor at Oxford, where he studied on a Rhodes scholarship, and he thought *The Hobbit* saga was a masterpiece. He translated Sappho, Heraclitus, Jesus, and Rilke, but he reveled in gossip. He rebelled against the prudery of his childhood, in a Southern Baptist family, in part by celebrating his bisexuality. (Some of his later stories and art are more explicitly homoerotic, courageously so for the time.)

Davenport's output was prodigious: nearly fifty books of criticism, poetry, drawings, cartoons, translations,

collages, fiction, and correspondence—and the hunger that drove his reading, from the age of ten, when a neighbor in South Carolina gave him his first book (one of the *Tarzan* series) never flagged. If his works have a common thread, it may be ardor. He relates the art of Balthus to the philosophy of Charles Fourier, the French utopian socialist who argued that all expressions of desire and sexual identity, including (especially) those of children, should be respected. "The nakedness of human nature is clothed so soon by every culture," Davenport writes in these notes, "that we are at a wide variance ... as to what human nature might be. It was one of the hopes of our century to find out, a hope wholly dashed."

A perfectionist is someone who despairs of perfection yet spares nothing in the vain attempt to achieve it. In that sense, Davenport and Balthus are kindred spirits. And also in that sense, every finished masterpiece is a work in progress that an exhausted maker had to abandon. It is useful to read these shimmering fragments with that warning in mind. They chart the struggle by which a true perception, feeling, or image comes into focus, even as they dramatize the truth that the wholeness of anything, or of anyone, is an illusion.

# A Balthus Notebook

## Guy Davenport

# 1

If there are eternal values in art, it seems they are pre-served only by those who strive to realize them in a new content.

## 2

Culture is not merely juxtaposed to life nor superimposed upon it, but in one way serves as a substitute for life, and in the other, uses it and transforms it, to bring about the synthesis of a new order.

# 3

If, as Robert Walser remarked, God is the opposite of Rodin, Balthus is the opposite of Picasso.

# 4

Mondrian, of Brancusi, "Ah! That great realist."

# 5

The reproach of escapism is seldom aimed at a painter; we do not hold it against Cézanne that he was living hidden away at Estaque during the war of 1870. And we recall with respect his "C'est effrayant, la vie," even when the lowliest student, ever since Nietzsche, would flatly reject philosophy if it did not teach him how to live fully (*à être de grands vivants*).

It is as if in the painter's calling there were some urgency above all other claims on him. Strong or frail in life, he is incontestably sovereign in his own rumination of the world. With no other technique than what his eyes and hands discover in seeing and painting, he persists in drawing from this world, with its din of history's glories and scandals, *canvases* which will hardly add to the angers or hopes of man—and no one complains.

What, then, is this secret science which he has or which he seeks? That dimension which lets Van Gogh say he must go "further on"? What is this fundamental of painting, perhaps of all culture?

# 6

Balthus's *Mitsou: Quarante images par Baltusz, préface de Rainer Maria Rilke* (1921) was published a year before Janusc Korczak's *Król Maciuś Pierwszy*. Balthus was thirteen, Korczak forty-four. Balthus had already done illustrations "for a Chinese novel," and between 1932 and 1934 he would do a suite of drawings to illustrate *Wuthering Heights*.

The conjunction of *Mitsou* and *King Matt the First* is on a ground of new responsibility and autonomy for children laid down in a diverse but coherent way by the Wandervögel in Germany and Scandinavia, Baron de Coubertin in France (and this would lead to the modern Olympics, though Coubertin's plan to include children would be thwarted), the Boy Scouts and Girl Guides in England and the United States (absorbing Ernest Thompson Seton's Woodcraft Indians movement); by Kipling in *Kim* and *The Jungle Books*; by Edgar Rice Burroughs (Tarzan was an adolescent when he became ruler of a forest kingdom); and by other forces moving children from their status as "the world's largest proletariat," as Korczak said when he undertook to be their Karl Marx.

*Mitsou* is only tangentially within this movement, but it is a book by a child, a category of which the world had hitherto been whimsically tolerant, and it is in the manner of Frans Masereel, the Belgian pacifist, exile (in Switzerland), and friend of Balthus's mother, Baladine Klossowska. Masereel invented the novel without a text,

using expressionist woodcuts instead. His first imitator is Balthus, his second Max Ernst in *La femme 100 têtes* (1929) and *Une semaine de bonté* (1933). This invention is actually a restitution of preliterate narrative art, as in church carvings and windows, the medieval woodcut, and prints in series, such as Hogarth's *Marriage à la mode* (1745) and *The Rake's Progress* (1735). The influence on Balthus of Hogarth is extensive and deep.

The forty drawings in *Mitsou* tell of a little boy (Balthus himself, as we can see from photographs) who finds a cat on a park bench, appropriates it, has many domestic adventures with it, and eventually suffers its disappearance. It is a love story with an unhappy ending. We can see in it the creation of a persistent symbol: the cat becomes Balthus's daimon as well as his alter ego. It is his representative in many paintings of daydreaming girls. It is his symbol of the animal in our nature. The cat is a sensual, cunning, sly, rapacious creature, easily tamed but never giving up its wildness, to which it reverts in fear, territorial wars, and mating.

Balthus painted himself once as a cat dining on fish, and once as the King of the Cats.

"In 1922, when he was fourteen," Sabine Rewald begins her book about him, "Balthus told a friend that he wanted to remain a child forever."

Korczak's *King Matt the First*, a masterpiece of children's literature in our century, has the power of *Candide* in its ironic bite and the charm that Antoine de Saint-Éxupéry would later achieve in *Le petit prince*. It is also a

book that was used in Korczak's orphanage in Warsaw as a cult text. In fact, it was written for the orphans. The story is of a ten-year-old king who rules with genius. He has the diamond-cutting rationality of Voltaire, Washington's nobility, and a mischievous touch of Tom Sawyer playing a king. His programs of reform reach their limit when he attempts to make a social class of children and urge them to revolt against grown-ups all over the world.

This, whether intentionally or not, was Fourier's vision of a New Harmony, principally designed for children, with a ten-year-old king as the final authority in the governance of all the world's phalansteries.

Pierre Klossowski, Balthus's novelist brother, tells us that Walter Benjamin's Marxism "was intent on safeguarding, in his vast erudition (conforming to a thoroughly lyrical sensibility), what in the past had constituted for [Benjamin] the 'shadow of the goods to come.' Among these goods to come figured the vision of a society blossoming in the *free play of the passions*. His nostalgia aspired to reconcile Marx and Fourier."

In a stratification that zones off children from adults (reminiscent of Rousseau's distinction between noble savagery and civilization) and assigns a native creativity and intelligence, along with a radical innocence, to children, we can place Balthus, who wanted to remain a child all his life, and who chose to meditate in so many canvases on the passage at puberty from child to adult. In *Mitsou* he meditates on the child's experience of loss,

folding in two symbols that would remain with him, the lively Mitsou of Colette and her loss (causing Proust to cry), and Mitsou the independent cat, which, having accepted Balthus's love and protection, simply walked away.

He sits, that cat, in canvas after canvas, playing Puck and commenting on what fools these mortals be, playing Balthus the grown-up, playing the Cheshire cat grinning in Olympian apathy.

One way of looking at Balthus is to see all the paintings as a complex *Mitsou* in which Colette's spritely girl has displaced her namesake cat, in which the form is now symphonic and rich in variations, with resonant quotations from Hogarth, Emily Brontë, Rilke, Courbet. A culture, Ruskin said, must be judged according to how it treats its children.

Balthus is well aware that we inhabit a world in which, on August 6, 1942, Korczak's Republic of Children, 192 of them, were marched by the Gestapo from the Warsaw ghetto to a train that took them to Treblinka, where, that afternoon, they were all gassed with the exhaust from trucks. Korczak led the procession, carrying a five-year-old girl named Romcia and holding the hand of another child, Szymonek Jakubowicz. At the end of the double file was a fifteen-year-old boy carrying the flag of King Matt, a Star of David on a white field.

In 1942 Balthus, a Jew by the Gestapo's reckoning, was painting meadows in the Rhone Valley, patient oxen, and children playing a card game called patience.

# 7

"Mitsou is resting, alone. She is wearing strawberry coloured stockings sewn on to her tights by the tops, a pair of gilt shoes and a mauve crepon kimono. Nature has given Mitsou all the advantages that fashion is demanding: very small nose, large eyes as black as her hair, round cheeks, a small, sulky, fresh mouth—that is her face. For the figure what is required is a slender body with long and well-shaped legs, and small and low-slung breasts; well, she has all that with only the small defect of a slight skinniness about the knee. But the thirties will fill up those page-boy's thighs, and also the back that is like an anaemic nymph's; Mitsou is only twenty-four.

"Mitsou is alone, sitting at her dressing table. Her legs, opened in a V, are held stiff so as not to strain her stockings, but her young back bends and her neck falls forward, as if she were a thirsty gazelle."

Colette's first description of Mitsou in *Mitsou, ou Comment l'esprit vient aux filles*.

# 8

Balthus's adolescents have a history. The Enlightenment, removing encrustations of convention from human nature, discovered the *durée* of childhood as the most passionate and beautiful part of a lifetime. (In Plutarch's *Lives*, no childhoods are recorded.) Rousseau, Blake, Joshua Reynolds, Gainsborough, Wordsworth.

By the Belle Époque, children (in a pervasive, invisible revolution) had come into a world of their own for the first time in Western civilization since late antiquity, and we begin to have (in Proust, in Joyce) dramatic accounts of their world as never before. Henry James's "The Turn of the Screw" (which now that we have Balthus seems Balthusian) is a skirmish on the border between the inner worlds of child and adult. James follows with symbols the serious misunderstanding between the interiority of two realms.

It is significant that anthropologists around this time, inspecting other cultures, thought of themselves as studying "the childhood of mankind." Balthus is a contemporary of Gide and Henry de Montherlant, who, like Fourier and Wordsworth, were trying to *place* the child's random vitality. Balthus's adolescents, in an endless afternoon of reading, playing cards, and daydreaming, seem to have come, we are told, as a subject for inexhaustible meditation from *Wuthering Heights*, a dismal and hysterical novel that he reads in his own way.

What caught Balthus's imagination in it was the manner in which children create a subsidiary world, an emotional island which they have the talent to *robin-soner*, to fill all the contours of. This subworld has its own time, its own weather, its own customs and morals. The only clock I can find in Balthus is on the mantel of *The Golden Days* in the Hirshhorn, and its dial is out of the picture.

Balthus's children have no past (childhood resorbs a memory that cannot yet be consulted) and no future (as a concern). They are outside time.

# 9

Modern French writing has been interested in childhood and adolescence in a way that American and English writing have not. The French see an innocent but an experienced mind in the child. Montherlant treats children as an endangered species needing protection from parents. Gide's understanding runs parallel, except that he makes allowance for the transformation to maturity. The child in Alain-Fournier, Colette, Cocteau, inhabits a realm imaginatively animated with a genius very like that of the artist. Children live in their minds.

Baudelaire saw genius as childhood sustained and perfected. There is a sense among the French that adulthood is a falling away from the intelligence of children. We in the United States contrast child and adult as we contrast ignorance and knowledge, innocence and experience.

We do not give our children credit for having arrived at anything. They have no driver's license, no money, no sexual emotions (and are forbidden them), no real sports they can play, no power. Balthus's children are as complacent as cats and as accomplished in stillness.

We have postponed fulfillment of heart and mind far too late, so that the spiritual rhythm, or bad habit, of American children is perpetual procrastination. American writing and art make the child an actor in an adult world (Mark Twain, Salinger), not a real being in its own.

Of the autistically interior, dreaming, reading, erotic, self-sufficient child in Balthus's painting we have practically no image at all. Balthus's children are not being driven to succeed where their parents failed, or to be popular, adjusted, and addicted to acquisitiveness.

# 10

Children are the creatures of their culture. The nakedness of human nature is clothed so soon by every culture that we are at a wide variance, within and among cultures, as to what human nature might be. It was one of the hopes of our century to find out, a hope wholly dashed.

In France this question was thoroughly and originally debated during the Enlightenment and Revolution. The building facing us in *The Passage du Commerce Saint-André* was Marat's newspaper office; the neighborhood once saw the movements of David and Diderot.

Charles Fourier concocted an elaborate philosophy to discover human nature and invented a utopian society to accommodate it, a society of children organized into hives and roving bands. Adults were, so to speak, to be recruited from the ranks of this aristocracy.

Proust's "little band" of adolescent girls at Balbec derives from Fourier, and the narrator's male presence among them is according to Fourier's plan of organization. Saint-Loup and his circle constitute a Little Horde, the complement of "Spartans" to the Athenian Little Bands.

# 11

Balthus's erotic sense disarms because of its literalness, explicitness, and evasion of vulgarity or cheapness of any sort. He brings the taste of Fragonard and Watteau into our century, where it is unlikely to survive except in Balthus's careful, protective sensibility. Watteau's ladies and milkmaids know that we are looking at them, and are forever beyond us in an imaginary world. Balthus's girls with bared crotches are usually looking at themselves, in a brown study or reverie, provocative, vulnerable, neither innocent nor naive.

The girl in *The Golden Days* is looking at her fetching self in a hand mirror and is sitting so that that young man feeding the fire will see her underwear, if any, when he turns. We see instead slim and charming adolescence trying on an expression for effect.

# 12

The term "modern artist" has never had a strictly temporal sense; from the beginning it has designated a totemistic clan to which one belongs according to a structure of rules with tribal overtones as yet to be described. Balthus is as yet a provisionally kin country cousin. Sir Herbert Read, for instance, decreed that Stanley Spencer was not a modern artist. We remember that Brancusi, to please a committee, had to redraw a portrait of Joyce because it wasn't modern enough for their taste.

Balthus, I suspect, has been excluded from the clan for reasons of awesome primitiveness, and has thus remained in the distinguished category of the unclassifiable, like Wyndham Lewis and Stanley Spencer. If modernity ended by trivializing its revolution (conspicuous novelty displacing creativity), it also has a new life awaiting it in a retrospective survey of what it failed to include in its sense of itself.

# 13

Balthus and Spencer illuminate each other. Spencer's intrepid religious grounding (eccentric, Blakean, British, Bunyanesque; the naive inextricably in harmony with the sophisticated elements) is like Balthus's privileged, undisclosed, but articulate psychology. Both painters express a sensual delight in the material world that is openly hedonistic, an accomplishment of their imaginations beyond the sensitivity of criticism: the way light rakes a brick wall in Spencer, the respect for carpentry and architecture in Balthus.

Both Balthus and Spencer give us the surface of the canvas as a mimesis of natural textures, not paint. In Picasso, Van Gogh, on out to the reductio ad absurdum of Pollock, it is paint. The difference is a philosophical one, perhaps even a religious one.

Spencer's iconography of saws, ironwork, human flesh reseen without the authority of neoclassical conventions, kettles, drying laundry, the location of shadows in naked light, parallels Balthus's return to a realism of an accomplished eye that demands accuracy of detail and that generalizes nothing.

# 14

We have yet to study in modern painting the choice of motif after the break between patron and artist in the early nineteenth century. Not even the portrait as a document or the landscape as a sentiment for a room's decoration survives this new context for the visual arts. This change was also a metamorphosis in taste. Malraux has his theory: that art became an absolute, that from Goya forward painting had only its authority as a witness to proceed with, alienated in one sense (from church and palace) but liberated in another to its own destiny.

# 15

Where in Greek writing you always find a running account of all the senses in intimate contact with the world, in Latin you find instead a pedantry accustomed to substituting some rhetorical convention for honest and immediate perception. Balthus has Greek wholeness. Nietzsche says somewhere that the Greek love of adolescents arose from the value they placed on their achievement as a people. The French woman, as a cultural type, recognizes her adolescence in Balthus's girls.

# 16

Balthus has the immediacy of a naive painter. Picasso's figures are all actors, wearers of masks, mediators, like Picasso himself, between reality and illusion. Pierrot, woman as artist's model, the Ballet Russe, the commedia dell'arte, dominate his entire oeuvre. Nowhere in Balthus does this theme of actor and theater appear (though he has designed for the stage and was a friend of Artaud). There is great integrity in his resisting it. His tradition stands apart from that of Rouault, Braque, Picasso, Klee, Ensor, and others for whom acting has been a metaphor and art a stage.

Nor do we find in Balthus any overt enlistment of mythology, which has been so characteristic of his time. No Venuses, no Danaës among all those girls. Even his cats and gnomes do not derive from folklore or myth. He is not part of any renaissance. His work is an invention.

Each painting is an invention, not the application of a technique. Each painting holds an imaginary conversation with some other painter, *The Window* with Bonnard, *The Farmyard* with Cézanne, *The Living Room* with Courbet, *The Dream* with Chardin.

*The Mountain* (in which the girl in the foreground stretches with the feline inflection of Gregor Samsa's sister at the end of *The Metamorphosis*) is a dialogue with the Courbet of *Rocks at Mouthier* (c. 1855) and *The Etretat Cliffs After the Storm* (1870).

# 17

These conversations among painters can be three-way, and complex. In *Nude with Cat and Mirror* the girl is from Simone Martini, and the cat, exactly quoted, is from Hogarth's *The Graham Children* (1742), an engaging painting in which a boy, entertaining his three sisters, thinks he is making a caged canary flutter by playing a music box, whereas the bird is fluttering because the family cat is staring at it and trying to mesmerize it. Is the cat in Balthus seeing itself in the girl's mirror? Balthus's painting is about virginity and desire, as all its iconography attests: bed, nudity, billet-doux, the brazier, the mirror, the transfixed cat. In both paintings the cat absorbs all the evil, leaving innocence to fill the rest of the space. A close study of Hogarth and Balthus will turn up many affinities.

# 18

In *The Visit* (1939), a surrealist painting by Paul Delvaux, we see a bare room in which a naked woman is sitting on a wicker-seated stool. Her hair is done in the style of a Victorian (or Roman) matron. She is cupping her hands under her breasts, as if to offer them to a sucking infant. Before her is a naked boy who is entering the room through a wooden door (scarcely matching the room's decorated ceiling and chandelier) that opens directly onto a cobblestone-paved street. The painting can only be of a dream, as the boy would not have been naked on the street, the door belongs to a humbler house, and the occasion for the boy's visit must be looked for in the realm of fantasy and must be generated by some anxiety about nudity, children, and adults.

Alex Comfort remarks in *Darwin and the Naked Lady: Discursive Essays on Biology and Art* that Delvaux is, among other things, showing us how our response to the painting is a matter of cultural rules. If the boy had wings, he would be Cupid, the woman would be Venus, and the painting would be a trite recycling of a classical theme.

Dr. Comfort does not go on to notice angels with trumpets painted on the Baroque ceiling (traditional accompaniments of Virgin and Child), or count the candles in the chandelier (six, the number on the altar). In most Madonnas, Jesus is naked to signify that he is without original sin, clothing being necessary only after the Fall.

Deviations from iconographic convention register as a transgression and take their meaning from the transgression, as with Max Ernst's *The Blessed Virgin Chastising the Child Jesus Before Three Witnesses* (1926).

Delvaux, whatever else he is doing in *The Visit*, is refilling the emptiness of drained symbols. Balthus is everywhere concerned with returning to subjects of perennial interest that have lost their immediacy and along with it their meaning.

Meaning is always of a wholeness. When Delacroix and Ingres painted odalisques, the harem constituted a critique of the body, its governance, the sources of power over it. An odalisque by Matisse is simply a model in a chair. From slaves and wage slaves to Balthus is the distance between slavery and liberty.

# 19

Meadow, farm, field, country town—Balthus's land-scapes are a return to Pissarro, to take up where he left off. Balthus is interested in the same continuities as in his interiors: the survival of certain manners, ways of spending time, intimacies of the bath and bed. Impressionism was devoted to roads, paths, rivers: a collective study of the network of roads that connected one French village to another. These ways were once ancient sheep paths, then market roads, then the highway system of the Romans. Impressionism was an assessment of civilization up to its time, as if prophetically aware that in 1914–1918 all this would be mud and trenches; seventy French cathedrals would collapse under artillery fire; a mode of life would be forever lost, *Swann's Way* (the name of a road) ends with automobiles in the Bois de Boulogne.

Cubism moved indoors, focusing on the humblest tabletops. Impressionism followed its logical study in Monet, back to the roadless France of prehistory—to the marshlands before they were drained for agriculture. That's what the lily pond at Giverny is, and the haystacks (winter fodder) are almost as archaic. But the beginning was with Pissarro's farms, fields, orchards; fields mea-sured out in baronial times, apple orchards as old as Gaul (apples came north with the Romans, as did the pear, Roman wheat, Latin, the engineering of canals and bridges, walled cities, strange Mediterranean gods).

So Balthus when he turned to landscape empha-
sized local geography, the specific character of particular
places, generalizing nothing. As his houses are without
electricity, without radios, TV, telephones; without bath-
tubs or faucets; his farms are eighteenth-century, using
horse and ox power. The figures in his landscapes wave
greetings. Van Gogh had painted farmers as drudges and
starving peasants. Balthus's farms are visions of pasto-
ral life.

Stephen Dobyns in his *The Balthus Poems* (in which
he writes poems about thirty-two of the paintings)
catches the tone of Balthusian pastoral in "Landscape
with Oxen":

> With the boards he will build a shelter for spring
> lambs that he will fatten in summer, sell in the fall,
> and of this pattern of seasonal routine he has woven
> a life much in the way his wife weaves the wool into
> thick cloth, into such a blue jacket as the farmer is
> now wearing, which the lawless wind tries uselessly
> to take from him.

## 20

Balthus's treatment of the human figure ranges from a *gaucherie* thoroughly primitive (crones, the boy with pigeons, that cat) to a sensuality and accuracy that put him among the master draftsmen. He paints from inside the figure outward, as if the figure painted itself.

# 21

The psychological acumen of the portraits of Derain and Miró is Shakespearean: speaking portraits in the common lore of what a portrait should be. They are, in a disturbing sense, too lifelike. And they are not here as painters primarily, but as the fathers of daughters. They are soliloquies in paint. (Chagall, around the time of the Derain and Miró portraits, had himself photographed with his twelve-year-old daughter wholly naked, achieving an homage to and subtle parody of Balthus, but recognizing his authority of innovation and iconology.)

## 22

The portrait of the Vicomtesse de Noailles, curiously like Wyndham Lewis's portrait of Edith Sitwell, is beguiling because of its honest, unflattering likeness and unconventionality of pose: a third-grade schoolteacher, surely, resting between classes. This portrait illustrates as well as any of Balthus's his ability to take the bare minimum of a subject and bring it to the highest pitch of clarity, of presence. This rich spareness contrasts with the century's aesthetic of merging figure and ground in a dazzle.

# 23

*The Passage du Commerce Saint-André*, Balthus's master-work, has the spaciousness and presence of a Renaissance wall painting (it is eleven feet long, ten feet high) and invites and defies a reading of its meaning as vigorously as Piero della Francesca's *Flagellation* (c. late 1450s). Reproductions of it trick one into believing that it is an intimist canvas, fairly small. I was unprepared for its size when I first saw it at the Centre Pompidou in an afternoon of surprises. I had just seen my first Tatlin and some late Maleviches unknown until then. I had seen an abstraction by Ivan Puni that made me feel for the moment that Western design still had everything to learn all over again from the Russians.

The surprise of suddenly turning and gazing into (not at) Balthus's great painting was a splendid and complex experience.

For the first time I remembered how familiar the street was to me, a locale I crossed time and again when I first knew Paris just after the war. The painting did not exist then, though Balthus must have been making studies of it, a picture to epitomize all his work, including the brilliant landscapes.

For just as *The Street* is conscious of being a displacement of a forest (with all its allusions to wood and the mythology of woods), so *The Passage* is conscious of being where a meadow once was. The dog is sheep-like, a man carries bread, and we are only a few streets from Saint-Germain-des-Prés, of the Meadows).

Inside the painting's mysteriousness there had been all along a familiarity I had not isolated until I stood before the canvas itself. A more wonderful way of seeing Proust's theory of the redemption of time in triumphant proof I cannot imagine.

Another surprise was to notice that for all the resonances in this most Balthusian of all Balthus's work (the Rilkean question, as of the Saltimbanques, "Who are these people?"; its kinship to Beckett and Sartre), it belongs with a rightness to the Paris of Simenon. There's the same flat ordinariness, as if to say: Look, the world is not really a mystery at all. It appears to be, but look again. These eight people, a dog, and a doll are the very essence of a Left Bank back street. The fine strangeness of it all is in our minds. The old woman with her cane, a concierge nipping out briefly to do her shopping, can tell you all about these people. She is the kind of spiteful old soul who gives Maigret and Janvier their best information. Our seeing the painting is very like Maigret's learning a neighborhood where a crime has been committed.

The figure we see from the back (a self-portrait, according to Jean Leymarie), who is coming from the baker's, is a standard type in the *quartier*. Maigret would suspect him of all manner of irresponsibility, bohemian attitudes, and cosmopolitan vices.

The man on the left, resettling his trousers, and the aging dwarf on the right are standard Simenon characters. They also belong to Beckett, a denizen of this street,

whose *Molly* and *Waiting for Godot* are contemporary with the painting in the Spenglerian and literal sense.

These gnomish creatures, the most accessible of Balthus's enigmas, are not satiric, symbolic, or archetypical. They are simply misshapen bodies for which Balthus makes a place in order to chasten his (and our) voluptuous taste for the world. Apollo is dull without Hobgoblin.

# 24

Balthus's earlier cityscape *The Street* states with more theatricality the theme of *The Passage du Commerce Saint-André*: that pedestrians on a street are preoccupied, sealed within themselves, without cognizance of each other. Each painting, *The Street* and *The Passage*, insists that the eye that's awake in all this sleep of attention is the artist's, making a basic definition, sweetly obvious but extraordinarily important, of what a painting is in the most archaic meaning of image, the *seen*.

# 25

We have adequate, if not accurate, reasons for the visual fields of all the epochs of graphic mimesis except the earliest and the latest. We feel confident that a Hogarth or a Goya exists in a history, an iconographic tradition, an anthropology that we can successfully examine. We do not have this confidence with prehistoric cave murals or with Balthus. We are as uncertain of Archilochus's exact meaning as of Beckett and Joyce. One pattern of meaning is lost, the other has chosen to move outside our received structure of references, to enlarge it.

In the two street paintings there is first of all a sense of absurd tragedy in the discreteness of the characters. Two adolescents, a boy and a girl, struggle playfully in *The Street*, unaware that they look like a rape, perhaps wholly unaware of the emotional forces disguised in their play. They are like the adolescents in the roomscapes who take poses that are erotically suggestive, ambiguous, tentative of symbolism. There's the same vagueness of purposelessness in Cocteau and Proust: the love scenes between Marcel and Albertine are all purest Balthus.

These adolescents are like kittens enjoying themselves immensely at a game of disemboweling each other. Their claws are retracted; we are fairly certain that they don't know what they are doing, though nature does. What does nature know about Balthus's pedestrians on a street?

Adolescents play at sex, a cook strolls on the sidewalk (if we don't know that he's a signboard for the menu), a

little girl plays with racquet and ball, a boy walks with a gesture like a bandleader's at the head of a parade, his face rapt with inner attention and Whittingtonian aspiration. A well-dressed woman steps onto the curb, seemingly in a reverie (is she gesturing to her child in the nurse's arms ahead?), a nursemaid in an apron carries a child wearing a sailor suit and reading a handbill, as awkwardly posed as a ventriloquist's dummy. There is something of Oskar Schlemmer's lay-figure poise and plumb-line balance to them.

Indeed, if we were told that we are looking at puppets, our eye immediately supplies their strings by noticing all the perpendicular lines directly above heads, wrists, and ankles that might be puppet strings visible for sections of their length: a metaphysical idea.

We remember Rilke's symbolism of puppet and angel in the *Duino Elegies*, the empty and the full, the fated and fate itself, and remember the iconography of the doll, straw man, and puppet in de Chirico, Eliot, Pound, Yeats, *Petrouchka*, Karel Čapek, Jarry, Carrà, Ensor, Wyndham Lewis.

These sentient puppets inhabit two simultaneous worlds: they yearn (inchoate yearning applies as subject to a good half of Balthus's work) and they are "tossed and wrung" (as Rilke says in the Fifth Elegy) by fate, like the figures in Picasso's Blue and Rose periods.

# 26

If Balthus's figure paintings are all purgatorial in the sense that brooding, looking inward, abiding patiently for things to come are modes of existential suffering, his landscapes are visions of paradise. Where the landscapes have figures, they are active and jubilant.

# 27

A work of art, like a foreign language, is closed to us until we learn how to read it. Meaning is latent, seemingly hidden. There is also the illusion that the meaning is concealed. A work of art is a structure of signs, each meaningful. It follows that a work of art has one meaning only. For an explicator to blur an artist's meaning, or to be blind to his achievement, is a kind of treason, a betrayal. The arrogance of insisting that a work of art means what you think it means is a mistake that closes off curiosity, perception, the adventure of discovery.

# 28

In curved Einsteinian space we are at all times, technically, looking at the back of our own head. (There's *mich*, me, in with *Marx* and *fox* and *moose* in the *Mookse* of Joyce's "Eins within a space and a wearywide space it wast ere wohned a Mookse.") In *The Passage du Commerce Saint-André* and again in *The Painter and His Model* Balthus has portrayed himself from the back. Fourteen of the thirty-five drawings of himself in *Mitsou* are from the back.

out on the sidewalk, the other holding her sleeping
child in her arms like a puppet.

This description is surely the product of a passing glance.
The "pair of schoolboys" are a fresh boy and a girl whose
skirt he is lifting (in an earlier version, bowdlerized by
the painter himself, the boy was groping the girl's geni-
tals). The "cataleptic baker" is a wooden sign on which
menus are posted. One of the women in black is stepping
up onto the sidewalk ("feet jutting out" may be static in
the translation), and the "sleeping child" of the other is
reading a piece of paper. As for the "beam" (more trans-
lator's static?), it is a plank, and probably a signboard,
and the figure's clothes are more likely those of a painter
than a carpenter.

The amorous boy and girl suggest an Ovidian episode,
perhaps an Apollo and Daphne. If Lévi-Strauss were to
begin a structural analysis of *The Street* with this percep-
tion, he would then connect the little girl playing with a
red ball with Peitho, Eros's sister. As we know from Ana-
creon, a red ball preceded Eros's bow and arrows as his
inflaming instrument. Wood, Daphne's transformation,
appears immediately as the wooden restaurant sign (eas-
ily mistaken, and in another reading of the painting, to
be taken for a real cook). Then what?

Or Lévi-Strauss might take another tack: we have
puppy love at one extreme, a nurse or mother with a
child at the other. In between, childhood at play, and
two professions (cooking and carpentry). We can read

# 29

Sensuous clarity, children in the old-fashioned sm[
of a France only recently folded into history for[
high-ceilinged rooms, Parisian streets, châteaux, fa[
meadows: Balthus's accomplished realism turns[
on inspection to be both a lyric vision and a comp[
enigma. *Ainigma*, Greek for "riddle." In the Old Te[
ment it means something terrible, defying understa[
ing; Paul uses it in "For now we see through a gla[
darkly: but then face to face …" "Darkly" is *en ainigm[*
as in a dark, puzzling, riddling saying: Paul is alludin[
to oracles, sibylline sayings.

Balthus is enigmatic in several masterly painting[
Of *The Street*, we would like to know if we are looking a[
surrealism, an old-fashioned allegory, a riddle, or a de[
ployment of symbols. We turn to critics for help. Here'[
Jean Leymarie:

> The white-clad carpenter carrying a beam as golden
> hued as the mystic wood is the axis of pure form
> and auburn light around which gravitate the othe[
> figures, a prey to their phantasms or sunk in thei[
> dreams: the pair of schoolboys caught at their little
> game; the cataleptic baker under his big white cap[
> the dreamy girl chasing a red ball that punctuates the
> grey street; the workman with a cap whose firm step
> and strange face come as a surprise; the two women
> in black, seen from behind, one with her feet jutting

the woman stepping onto the curb as the mother of the child in its nurse's arms.

All of this keeps suggesting an allegory.

If we see the boy and girl as an allusion to a classical erotic pursuit, a good candidate for the allusion is the grasping of a nymph by Zephyrus in Botticelli's *Primavera* (c. 1480).

Indeed, if we put the one painting over the other, with Botticelli reversed, we discover that the nine figures in the one correspond to each of the nine in the other: Cupid (corresponding to Balthus's Peitho with the red ball), Mercury (corresponding to Balthus's messenger boy), Venus (who in gesture is like Balthus's woman in black stepping onto the sidewalk), Flora, a nymph, Zephyrus, and the three Graces.

Now the iconographic enigmas start to do all sorts of witty things. The Graces are Aglaia (Splendor), who presided over victories at the games (is she our tot with the racquet and ball?); Euphrosyne (Mirth), who presided over good spirits and happiness (our marching messenger boy?); and Thalia (Abundance), who presided over festivals and feasts and later became the muse of comedy (our wooden cook?).

These three figures make a zigzag among the others, like the sidewalk on the left.

Globe and circles at the top of the painting correspond to Botticelli's grove of golden apples.

A street is the traditional stage for comedy. *The Street* seems to have absorbed comic motifs from Plautus

to Hogarth. (The restaurant sign, a saint with a cup, is Hogarthian.)

In Christian iconography the three Graces become Faith, Hope, and Charity. If we continue the singular line between the outermost and the next red stripe on the bistro awning at the right, we discover that it ends exactly at the painting's bottom left corner. The resulting triangle encloses a woman with a red cross on her hat (Faith), an aspiring and confident messenger boy (Hope), and a nurse carrying a child (Charity).

Note how the man carrying the plank (which several critics have read as Christ with the cross) divides the composition into two groups, each of which contain a child, youths, and adults.

The child being carried is reading, myopically, out of the side of his eyes. So are we, in all this speculation. So are we.

# 30

Like his childhood mentor Rilke in the Fifth Duino Elegy, Balthus asks in his studies of so many adolescents who we are in our cycle of budding, blossoming, falling to seed again "in diesem mühsamen Nirgends." Our "never-contented will" pitches us like acrobats even in boredom and contemplative repose. Rilke was meditating on Picasso's *Les saltimbanques* (1905), and Picasso's gesture in buying and leaving Balthus's *The Children* to the Louvre as part of the Donation Picasso seems a deliberate return of Rilke's homage, thereby defining the kinship of three symbols of *Dastehn*, the existential *thereness*—the Saltimbanques, from which came the Fifth Elegy, from which came *The Children* of Balthus.

# 31

Another work, indeed, in time an oeuvre, that came from *Les saltimbanques*, is the earliest surviving story of Eudora Welty, "Acrobats in a Park." This story, written "in, or about, the year 1935," was turned up in the Mississippi Department of Archives and History in 1967 by Kenneth Graham of the University of Sheffield, who published it in *Delta*, a journal published at the Université Paul Valéry in Montpellier. It was again published at Clemson, with an introduction by Jan Nordby Gretlund, a Danish scholar of American writing. The story is a kind of translation of Picasso's figures into a family of itinerant acrobats. Welty makes them part of a circus performing in her native Jackson. In an introduction to the story in 1980 she wrote:

> Under the guidance of instinct, I made the acrobats into a *family*, and set them down on the ground in Smith Park in Jackson.... In performance, their act had been the feat of erecting a structure of their bodies that held together and stood like a wall. When I was writing about the family act, I was writing about the family itself, its strength as a unit and its frailty under stress....
>
> What strikes me now, and what I was unaware of then, was that these acrobats were prophesying for the subject that would concern me most in all my work lying ahead. From points of view within and

without, I've been writing about this Wall ever since and what happens to it. Indeed, in this story are the beginnings of the subject in its double form: the solid unity of the family thinking itself unassailable, and the outsiders who would give much to enter it—most often out of love and with the effect, sometimes, of liberation.

# 32

Picasso liked to paint his own children in the costumes of the acrobats of the Blue and Rose periods, to emphasize that the vulnerable and wan people he painted then were indeed families (and how many Holy Families he has slipped into his circus people, only half disguised) and that their coherence was as frail as Eudora Welty intuited.

Balthus has painted some of his most hauntingly impressive portraits of fathers and daughters, of families, of husbands and wives, though it is the daughters on whom his fame rests.

# 33

Balthus's adolescents are Rilke's "bees of the invisible," taking in from books, from daydreaming, from an as yet ambiguous longing, from staring out windows at trees, sustenances that will be available in time as Proustian ripenesses, necessities of the heart.

Ultimately it is Balthus's sensibility that gives his canvases their distinction, the quality of his attention, the unlikely subtlety and boldness of his sensuality, the harmony he creates of tensions, inarticulatenesses, ambiguities, volume, light, elusive moments.

# 34

As Saussure could not, or would not, define language, so we should not define art, which may be a granary door in Ogol or Brancusi's *The Kiss*, a film or a Mycenaean shield. Nature without art is signless and brutal, but "real"— and here reality means survival tactics (feral caution, stalking, fleeing, mating, abiding, identifying a territory in which somebody else, not us, is the stranger). Culture, having art for sign, is symbol, rite, custom, and is "unreal." Is the dividing line between nature and culture the imagination? From which invention, language, number, proportion, manners. Is misbehavior a recourse to nature, or a malfunction of culture, or simply a breach of the ethical code with which we control nature and ourselves in society? Culture and its ground, agriculture, are the prime Balthusian assertions. His largest theme may be the care a culture has for its young.

# 35

Balthus's paintings are illustrations for a writer we can imagine the style of, but who doesn't exist. This writer would have Francis Ponge's metaphysical sense of French meadows, Proust's sensuality of girls' bodies and clothes, Rilke's ripeness of fate and time. But what writer can deal with the happy fat boy and his pigeons, the Japanese woman in her Turkish room, the crones and gnomes, the daimon cats, part Cheshire, part hearth-god?

# 36

The large glass fruit dish on a silver base which a baby is trying to reach in *The Greedy Child* appears again in *Still Life with a Figure*. In the former it contains peaches and plums; in the latter, apples. Sabine Rewald gives the title of *Still Life with a Figure* as *Le goûter*, "The Snack." A taste, a between-meals meal, is the sense of *goûter*, and the word comes from *gustare*, to be pleased by taste. Our word *choose* derives from the same root.

Apples, wine (or cider), bread with a knife left in it mid-slice. A girl looks at it all, one hand on the table, the other against a large tapestry, or curtain. This cloth is lifted so that its largest fold has a depression resembling an adolescent vagina. The appearance of such a drawn-back curtain in Christian iconography "signifies the revelation of a sacred space." The still life, except for the apples, is eucharistic; the bread and wine of the mass persist in still life, and began before Christianity in the painted meals (to sustain the dead) in Egyptian tombs as well as in Old Testament imagery (Amos's "basket of summer fruit" symbolizing God's bounty).

The apple comes late in Balthus. It is not used insistently or programmatically as a symbol of the Fall; it is an adjective, not a verb. It occurs in the paintings that meditate on the transition from girl to woman. They occur in the same glass bowl in *The Living Room*, where a rite of passage is depicted: a dreaming girl on a sofa, a girl kneeling on the floor and reading. There's a score

open on the piano; the tablecloth (analogue of skirt) has been pushed back to reveal part of the tabletop. The red apples say that Balthus thinks of maturity in Judeo-Christian terms: a fall, a *felix culpa*. In Fourier's Harmony, the Little Bands and Little Hordes of children will think of their older members who have begun sexual experiences as fallen angels.

A basket of apples sits on the floor in *The Three Sisters*. The trees in *The Triangular Field* are apple.

The orange in *The Golden Fruit* (the golden apples of mythology were probably oranges) and the unidentifiable fruit in *The Turkish Room* (surely not eggs, as Rewald says) serve the symbolic function of apples.

In Christian iconography, a pear symbolizes the Redemption, and apple and pear are frequently together in Madonnas, Mary being the redemption of Eve, Christ of Adam.

In the eloquent *Painter and His Model* of 1981, in which Balthus is opening the curtains of his studio (rhyming with the gnomish figure opening the drapes in *The Room*) and the model, fully dressed, is kneeling at a chair and looking at a drawing (rhyming with many kneeling, reading girls), the tabletop still life is of a box of biscuits (wheat field, meadow) and two apples and a pear, triumphantly together for the first time in Balthus's work. There is also a ladder in this culminating painting: traditional symbol of spiritual climbing.

# 37

Eighteenth-century satire became nineteenth-century observation. In the twentieth century, observation became surreal. It became an ironic sensuality, and the basis for satire, which was once moral, became irony. As if by attraction, or even kinship, observation, along with its concerns for sentiment and social justice, followed satire to sit on its new ironic base. Thus surrealism in the hands of Max Ernst or R. B. Kitaj became a classical mode of the century and reinforced the century's characterization of reality as an enigma. "The great Surrealists, for me," Kitaj has remarked, "are not the orthodox Surrealists, who are generally lesser artists, but people like Picasso, Bacon, Balthus."

The master figures at the heart of surrealism, Ernst, Chagall, and de Chirico, have made a metaphysical poetry of modern painting, moving between the extremes of the collage to the fantasy of folktale or dream.

Balthus's space in all this may well be outside surrealism altogether, while enjoying diplomatic relations. Kitaj's parody of, or conversation with, *The Street*—his *Cecil Court, London WC2 (The Refugees)* of 1984—is more a spoof than a sustained parody. Its stretched Chagallian figure and allusions to private associations show the likenesses and differences of the two painters. Balthus's subjectivity is absorbed completely; Kitaj's is allowed to remain on the surface, to create a turbulence where Balthus insists upon a calm.

# 38

One becomes inured to the hard truth that reality is a function of dreams, that things are perceived according to what they symbolize, which is what caused them to be selected in the first place from myriads of others, all competing for attention. Symbolism is the language of dreams.

# 39

Baudelaire, in *The Salon of 1846*: "Many times, when faced with these countless samples of the universal feeling [erotic drawings], I have found myself wishing that the poet, the connoisseur and the philosopher could grant themselves the enjoyment of a Museum of Love, where there would be a place for everything from St. Teresa's undirected affections down to the serious debauches of the ages of ennui. No doubt an immense distance separates *Le Départ pour l'île de Cythère* from the miserable daubs which hang above a cracked pot and a rickety side-table in a harlot's room; but with a subject of such importance, nothing should be neglected. Besides, all things are sanctified by genius, and if these subjects were treated with the necessary care and reflection, they would in no wise be soiled by the revolting obscenity, which is bravado rather than truth."

# 40

Stanislas Klossowski de Rola protests in an introduction to a book of his father's paintings that "the fabled theme of the young adolescent girl, which Balthus has treated repeatedly, has nothing whatever to do with sexual obsession except perhaps in the eye of the beholder." This is ingenuous, and fair enough, but what's being said here? Whatever I might know about the artist's obsessions (which in my case is nothing), that knowledge would remain irrelevant, and the paintings would remain unchanged.

"These girls," he continues, "are in fact emblematic archetypes belonging to another, higher realm." This assertion is unfair to Balthus's penetration into privileged female space, rivaled only by Vermeer and Degas. So human and valuable an understanding should not be diminished by Neoplatonic Jungian jargon. Balthus's girls are sexy, charming French adolescents painted with a fresh reseeing of the human body, with humor, with wit, with clarity, and with an innocence that we can locate in adolescent idealism itself rather than in an obsession.

The young body has not yet accepted the permanent mask of clothing, as the faces of the young are not yet masks. It seems to me wrong to see a philosophical abstraction when the artist has given us flesh and blood, a perfection of tone and moment, a magic stillness of time, accurate perceptions of moods which few painters or poets can equal.

*Young Girl at a Window*—a girl with her left leg resting on a chair, her arms on a windowsill, seen from behind, looking out on boughs, bushes, a barn—defines so well the pensive quiet of the moment that archetypes and emblems add nothing to the painting's beauty or its success. The girl is civilized, the house bespeaks a culture, as do the barn and the trees. Balthus is indeed painting adolescence but, more important, adolescence in this particular French place. Subject and symbol are fused inextricably. Great art is always eloquently tautological; the world in Balthus is a metaphor of itself.

# 41

In the Wittgensteinian convergence where *Ethik und Aesthetik sind Eins*, we can locate a subsistent morality far more cogent for Balthus than Stanislas Klossowski de Rola's "higher realm" of archetypes. Centuries before Plato, beauty was a kind of good, and the appreciation of it a pleasure. Beauty has also traditionally been an outward sign of the soul's beauty. Balthus integrates this ancient tradition with Darwinian naturalism (beauty as sexual attraction). Darwin suspected that there was always "something left over" after sexual attractiveness had done its work, and that this something was what we call beauty, and that it may have given rise to art. The grace of line in a Lascaux horse is not the horse, but something that has been abstracted from it.

The puritanical objections leveled at Balthus are fueled by prurience equating candor with misplaced desire. The objection to desire is not moral but economic. A woman's body is marketable; its sexuality is not to be recognized in any but an economic context.

# 42

Apple is both discord and harmony. Pear is concord, sweetness, harvest bounty. Eve's *malum*, meaning "evil" and "apple"; and there's the resemblance of glans penis to an apple). Theocritus VII: Eros compared to a red apple, Philinus (the beloved) to the mellow ripeness of a pear.

Pear: Castor and Pollux, friendship of teacher and pupil, artist and model. Leda's egg: apple (Helen) and pear (the Dioskouroi).

Apple and pear in Balthus's *The Painter and His Model* are a symbol (however we arrive at it through the Greek, Roman, and Christian grammar of the erotic apple and the friendly pear) of the bonding of the artist and model.

The artist is opening the curtain at the window, as the dwarfish gnome does in *The Room*. Tasks assigned to goblins from the underworld thirty years before are now the duty of the artist himself. Is this a discovery that the dark of intuition is always illuminated by the process of creation? This is a good example of what Freud seems to have meant when he said that the *it* of the subconscious can be the catalyst of the integrated, wise self. The troll under the mountain emerges with the gold. There's a ladder in the painting, symbol of ascent.

Art in the twentieth century is best characterized by its redemption of time in its own terms. Picasso's final meditation on the erotic agony of the flesh, his *347 Suite* (1968), has for its final plate a meadow before a wood, and a serene artist and model. Kafka's last story is set in a meadow, and is a fable about the powers of the artist.

# 43

It is precisely those harmonies which have become dissonant we want to study in every way we can, for they had a harmonic origin. They changed. We changed. We need to know why.

# 44

Balthus, like Kafka, is a master of gesture and posture. For Kafka the body was a semaphore transmitting a language we cannot read. Balthus's gestures also defy interpretation. The luxuriant stretch, ecstatic comfort, looks out of the side of the eyes—these reserve meaning that would be apparent in Goya and Hogarth. They are Kafka's existential kinetics.

# 45

A theater of silence. A film about Balthus (Fellini has considered making one) would want César Franck or Mozart for its soundtrack. The voice-over might plausibly be the First and Fifth Duino Elegies, Ponge's *The Meadow*, Proust, Gertrude Stein.

# 46

When we place Balthus beside the intimist painting
of Denmark, especially Købke and Hammershøi, with
whom he would seem to have a similar feeling for in-
terior space and for landscape, we see instead his phil-
osophical difference. There is an awesome existential
bareness in Balthus. He is not, however, a nihilist like
Nabokov, rejecting all humanism along with humanity
itself. He is closer to Beckett and Ionesco than to Sartre.
There is the ungiving understanding that what's of value
in life is inherited from the past. In the present we have
healthy bodies and their fate, nothing else. Our century's
events do not exist in Balthus. His portraits are of art-
ists and friends. The canvases done during the Second
World War are of farm life and girls in provincial houses.

# 47

If surrealism tried to find a European subconscious
mind that is kin in irrationality and mythic structure
to primitive cultures (it has been noticed that French
ethnology and surrealism have mutualities and affin-
ities), Balthus has worked not with spiritual substrata
where civilization and barbarity have common roots, but
with the high surfaces of civilization (the ancient farm,
the studio, well-furnished rooms, the streets of Paris). A
commentary on any of the paintings will extend deep
into history, biography, and rich iconographic detail.

# 48

Balthus's awkwardnesses, as in the early paintings and the Brontë drawings and later in sporadic passages, are deliberate. They happen well after he had achieved a sophisticated style. They are like Beckett's writing in French because he felt that his English was too facile. Balthus's use of rough surfaces in his Roman period served the same purpose: to humble facileness.

In these awkwardnesses we see a kinship with Henri Rousseau, who in many ways is Balthus's secret master. Compare *The Poet and His Muse* (1909) with the portrait of Derain. Each eludes the neoclassical in its own way.

# 49

In the course of an essay praising the painting of Anita Albus, Claude Lévi-Strauss makes this observation: "The history of contemporary painting, as it has developed during the last hundred years, is confronted with a paradox. Painters have come to reject the subject in favor of what is now called, with revealing discretion, their 'work' [*travail*]; one would not be so bold as to speak of 'craft' [*métier*]. On the other hand, only if one continued to see in painting a means of knowledge [*un moyen de connaissance*]—that of a whole outside the artist's work—would a craftsmanship inherited from the old masters regain its importance and keep its place as an object of study and reflection."

Lévi-Strauss ends each of his four volumes of *Mythologiques* with a critique of the confusion into which art, philosophy, and civilization itself have fallen. Music has lost its harmony, literature its resolving plot, painting its skill in interpreting the world. In abandoning a discipline of the self (Michel Foucault's last subject), we have reversed the deference to nature in which civilization began. We must move away from Sartre's "Hell is other people." The crux is this: that instead of asking the world not to threaten our solitude, our personal and solipsistic order, we should so behave ourselves as not to threaten the world's order. This involves our understanding, and agreeing to, the world's order, a process of complex immensity, but one in which culturally the arts have a great, mediating, role.

Lévi-Strauss allows Max Ernst and Anita Albus the distinction of being true artists. We can, without violence to his strict demands, include Balthus, along with others. If the artist imparts and structures a knowledge of the world, he must speak so individually and with such fresh insight that his work extends rather than duplicates knowledge. He must give us new eyes. He must educate our sensibility.

In time, we will see Balthus as kin to Joyce on the one hand (our biological mandate civilized by a poetry of desire and its constraints), and to Proust on the other (the tragedy of time illuminated by the beauty and wonder of being alive).

# 50

What is Balthus? The Blue and Rose periods in color and translated from Montmartre to the Faubourgs Saint-Germain and Saint-Honoré, to châteaux in the Rhone Valley? Courbet in the age of Rilke and Cocteau? He is, most certainly, the artist whose vision of the French spirit will increase in subtlety and radiance.

# 51

Henry de Montherlant, that stoic and sensualist whom
fate dropped into the France of our time rather than
into the Roman consular service of the second century
where he belonged, answered a critic's query as to "the
great men who had influenced him most" by naming
Pyrrhon of Elis, Anacreon, and Regulus, "le Sceptique,
le Voluptueux, le Héros." He added that their influence
was a single force. "Do not consider any one of them
without the other two." It is doubtful that the Pyrrhon
we know about resembles with any accuracy the philos-
opher of that name; Regulus is certainly a myth; and we
wonder which Anacreon Montherlant had in mind, the
anonymous author (or authors) of the Alexandrine imita-
tions, or the poet whose work survives in such mutilated
form that we can only guess what it was when whole?
Balthus might answer the question with Rilke, Courbet,
Proust; or Emily Brontë, Vermeer, Colette. We would be
cautioned, as by Montherlant, that the influence is an
integration of forces. And Balthus is rich in *hommages*:
a still life bows to Morandi, a hand holding a mirror to
Utamaro, a cat to Hogarth.

# 52

Balthus, like Daumier, allows caricature beside tradi-
tional academic rendering. So does nature. Velásquez's
dwarves and midgets serve to place an infanta or king in
the chain of being as his society understood it. There is a
profounder meaning to Balthus's ogres: they belong with
the voluptuousness of his girls, for sex, when it comes,
will be goblin as much as it will be Eros. Priapus is a
homely and earthy god. Look at the goblin in Fuseli's
*Nightmare* (1781).

# 53

Balthus works in an imaginary space between interior and exterior worlds. What we see in his paintings is not what a photograph would record: certain cats and human figures would be missing. The man laying the fire in *The Golden Days* may well exist only in the imagination of the girl studying her face in a mirror. In *The Room* we can plausibly read the painting as having one figure only. The stunted woman may be imagining the luxuriating girl. The strolling "cook" in *The Street* is a flat restaurant sign. Is the walking figure in *The Dream* a dream?

## 54

Picasso painted in the Latin of the Principate, when portraiture became big-eyed and staring, the human form became stiff and heavy, and the world was fascinated by but weary of violence. Braque painted in Greek. Balthus paints in the patrician French of Henry de Montherlant, aloof from vulgarity.

# 55

*Mitsou* is contemporary with Rilke's *Sonnets to Orpheus*, and is itself a version of the Orpheus myth.

# 56

Octavio Paz ends a poem dedicated to Balthus with "La luz es tiempo que se piensa" ("Light is time thinking about itself"). "La vista, el tacto" ("Sight, touch") meditates on the tactile abilities of eyesight, on light's sculpting matter, so that we see it according to the strategies of light on objects. In modern painting we have two traditions of light. One analyzes light as a vibrant rain. From Pissarro and Cézanne to Seurat and Signac we see the physics of color, the dance and ricochet of the photon, a granulation into discrete particles.

The other tradition ranges from the blind fingers of Picasso to Balthus's treatment of light as a transparent solid in which matter is submerged. Heraclitean fire, the one; Aristotelian solidity, the other. In Monet light visits the haystack; in Balthus light embraces, fuses, clings.

# 57

A culture's sense of the erotic is a dialect, often exclusively parochial, as native to it as its sense of humor and its cooking. Sexuality being a biological imperative, we imagine that we comprehend Manet, Fragonard, and Watteau when their subjects are erotic; Goya, Rubens, and Rembrandt; Greek, Japanese, and Dogon erotic art. Each culture has its taboos, its lines drawn between decency and the obscene. These can be absurd, prudish, religious, bourgeois, legal demarcations. Because they are proscriptive, causes of anxiety, shame, and salacious humor, these cultural decisions about sexuality become richly symbolic.

The nearer an artist works to the erotic politics of his own culture, the more he gets its concerned attention. Gauguin's naked Polynesian girls, brown and remote, escape the scandal of Balthus's, although a Martian observer could not see the distinction.

# 58

Textiles with floral designs are indoor meadows in Balthus. As the meadow itself is his prime symbol of nature and the pubescent female body his symbol of spirit integral with matter, the two together are his *signum mundi*. The Turkish or Persian carpet is in fact a token meadow, the floor of the Arab tent, prayer rug, dining space, bed. Northern Europeans used these beautiful carpets as table covers and wall hangings, as we can see in Holbein. Meadow and pasture in the Old Testament become the ground for Jesus's pastoral images, and in Greek poetry as early as Sappho and Archilochus the erotic affinity between meadow and girl which will persist through medieval and Renaissance art (in the Provençal poets, Petrarch, Chaucer, Shakespeare) is already a mature convention. We find in the Cologne fragment of Archilochus:

> I said no more, but took her hand,
> Laid her down in a thousand flowers,
> And put my soft wool cloak around her.
>
> I slid my arm under her neck
> To still the fear in her eyes,
> For she was trembling like a fawn,
>
> Touched her warm breasts with light fingers,
> Straddled her neatly and pressed
> Against her fine, hard, bared crotch.

Sappho, imagining a girl who is now grown and a wife in Sardis:

> And now she moves among the Lydian ladies
> As when the sun has set and the stars come out
> And the rose-red moon
>
> Lifts into the midst of their pale brightness.
> Her light is everywhere, on the salt-bitter sea,
> On fields thick and rich with flowers
> And beautiful under dew,
>
> On roses, tangled parsley, and the honey-
>      headed clover.
> Her light is everywhere, remembering
> Atthis in her young sweetness, desiring her
> With tender, heavy heart.

In *The Toilette* Balthus has placed a standing adolescent, nude save for white knee socks and red slippers, before a bed with a flowery eiderdown. *The Cup of Coffee*, an essay about its motif, meditating on its descent from the odalisques of Delacroix and Ingres through Matisse, places a girl in an arabesque of carpets and floral textiles. *The Turkish Room*, *The Three Sisters*, *Sleeping Nude* also deploy girls on a ground of meadow carpets.

# 59

Chardin painted in an age of conversation, Rembrandt in one of argument and disputation: both depict objects found in darkness by a remote light. Chardin's light is mellow, kind, sweet. In Rembrandt light hallows what it illumines while it fights the darkness. Chardin's light is reason; Rembrandt's, faith and revelation. Balthus's light is a plenum, as thorough, pedantic, and secular as a page of Sartre.

# 60

Eakins and Balthus. Their differences are many: Eakins has none of Balthus's irony, wit, or comedy. Their sensuality, surprisingly, brings them together, for both insist that the body has a mind, and that its intellectual, speculative, thinking life is integral to the sensuous life of the body. They share a candor expressed in exactitude and honesty. Eakins shared Whitman's vision of the erotic, and painted wrestlers as intimately entwined as lovers, and male swimmers as comradely as in an Athenian gymnasium frequented by Alcibiades. All of Eakins's work is of thinking, skilled, accomplished people: mathematicians, athletes, poets. Eakins painted the arrived; Balthus, becoming. Both explored private, privileged space, with nudity as the occasion for their tact.

# 61

In wanting the modern Olympics to include children, to be played in the nude, and for there to be no spectators, Coubertin showed a hopeless ignorance of what the world outside his study had become. Children were an Arnoldian (as well as classical) touch: the green playing fields of England, where the cricketers and ballplayers could read Thucydides in Greek, Horace in Latin, Ronsard in French. The nudity was from the ancient games themselves, and the banishment of spectators his aristocrat's distrust of a crowd's idle curiosity. Spectators smacked of the drunken, vicious dandies who watched boxing and cockfights in a morbid pursuit of excitement. Spectators were ignorant of sport, devoid of idealism, and avid merely to be amused. But Coubertin seemed to have no notion that sport in modern times would be precisely the Circus Maximus all over again, with the crowd hoping to see the athlete break his neck, the racing-car driver die in burning gasoline, soccer teams brawling.

Balthus disappoints many expectations by being from Coubertin's deployment of values. He is never vulgar, never paints in the vernacular. And his idealism is as vulnerable as Coubertin's to journalistic acid and public opinion.

# 62

"When he was nineteen years old Picasso came to Paris, that was in 1900, into a world of painters who had completely learned everything they could from seeing at what they were looking. From Seurat to Courbet they were all of them looking with their eyes and Seurat's eyes then began to tremble at what his eyes were seeing, he commenced to doubt if in looking he could see." ("Seeing at what they were looking" for "looking at what they were seeing" and "from Seurat to Courbet" for "from Courbet to Seurat" are Steinian games with *our* eyes.) Balthus's eyes have never doubted. The decisiveness and radiant clarity of his landscapes were achieved in faith, loyalty, and reverence. They are a rebeginning after impressionism, and have learned from it.

# 63

Basil Bunting, the Northumberland poet, found another reason to damn the shallowness and ignorance of our times in that he had reached a great age before he saw the painting of Balthus. Yeats was luckier. Federico Fellini, writing about Balthus in awe and reverence, calls him the master custodian of our heritage in painting. Balthus was admired and collected by Picasso and Albert Camus, yet American critics with a few exceptions have denounced him for both his subject matter and his style. He inspires in them a hysterical prudery that has taken such diverse forms as attacking him as a pornographer and as being a false claimant to his Polish title.

# 64

*The Passage du Commerce Saint-André* is in conversation with *La Grande Jatte*. With Jules Laforgue as an interpreter, if the Belle Époque can't quite believe postwar Paris in the 1940s. Both paintings comment on the Revolution. French dialogues with the past are distant or close: Roland Barthes might have been one of Gide's sensitive adolescents. Poulenc converses with Machaut, Picasso with Poussin, Braque with Chardin. Balthus goes back to Balzac, for whom reality was magnificent in its monstrous ugliness, for whom youth was at once silly and beautiful.

Both paintings depict a Sunday. The old woman in the *Passage* will have lived through the two intervening world wars.

# Afterword

## On Davenport (Who Also Wrote Well About Art)

Lucas Zwirner

After studying at Duke, Oxford (where Tolkien's tutoring bored him to death), and Harvard, Guy Davenport took a job in Kentucky, far away from the centers that housed so much of the culture he wrote about. When asked why he chose Kentucky, Davenport famously said: The farthest away and the highest pay.

From his remote seat in Lexington, Davenport went on to produce some of the most astonishing prose ever written by an American: Hobbits, Picasso, the history of the Mediterranean, spy novels, John Ruskin's life, and Wittgenstein's last words all fell within his purview. As in the case of the greatest essayists (Montaigne their progenitor), the anecdotal, historical, factual, and mundane mix easily, lightly even, only to reveal the depth of a writer's insight. When discussing Montaigne, Davenport turns to Plutarch, whose *Parallel Lives of Noble Greeks and Romans*, a book about people and their lives, was the template for Montaigne's craft. Essays, at their origin, are personal; character, it turns out, is not an impediment but the key to understanding someone's thought. "It has been said of Montaigne, and can be said of Plutarch, that in reading him we read ourselves." The work both reveals and is revealed by personality, on both sides.

Of Ruskin, Davenport says:

His energy was boundless. He never passed up a game of chess (and kept games going by mail). He loved the theater (the more vulgar the play, the better), the

Christie minstrels, military bands, dancing (he could do a memorable highland fling).

And a bit earlier in the same essay ("Ruskin"): "He learned everything except the facts of life."

Who can write like this? We feel we *know* Ruskin, and we do because everyone Davenport read became a friend to him, an intimate. He got to know them all by listening closely, sounding them out, and like Ruskin's writing, which is "not writing but speaking," Davenport's is "thinking aloud." It's no surprise that the essay he is best known for is called "The Geography of the Imagination," which introduces us to such a rich and diverse imagination in Davenport himself that we are forced to expand the limits of our own maps. New countries emerge, spanning centuries and disparate continents. As he puts it at the very beginning of the essay:

> The difference between the Parthenon and the World Trade Center, between a French wine glass and a German beer mug, between Bach and John Philip Sousa, between Sophocles and Shakespeare, between a bicycle and a horse, though explicable by historical moment, necessity, and destiny, is before all a difference of imagination.

Davenport's imagination of people, of the world, of history and its contingencies, reveals everything we need to know about him, and a lot about ourselves. Thinking

through culture was his gift, and he practiced it like a poet, setting things in proximity to each other so that they draw out unseen implications, writing obliquely so that as readers we can furnish fresh connections and learn to imagine ourselves.

In *The Notebooks of Malte Laurids Brigge*, Rainer Maria Rilke writes that poetry is only possible once memories "have changed into our very blood, into glance and gesture, and are nameless, no longer to be distinguished from ourselves." You could say the same about Davenport. Literature, philosophy, the lives of thinkers, and the rhythm of prose became blood and bone in him so that when he wrote, his thoughts were organic, shaped to his subjects. His thinking feels like portraiture—the kind that exposes as much about the person in front of the camera as the person behind it. Think of Wolfgang Tillmans, for example, or Alice Neel. Davenport was an artist disguised as an academic living in Kentucky. He was drawing seriously long before he learned to read or write, and portraiture of all kinds would remain his natural form. He wrote beautifully about visual art. But among the forgotten writings of Davenport (and hardly any are widely read today) his essays on visual art are the most forgotten of all.

2

Art history is a discipline that privileges its practitioners, and Davenport was decidedly not one of them. Of Picasso, he says: "He stepped over the moment of Cézanne, Manet, Courbet like a giant negligently striding over a garden whose order and brilliance were none of his concern. All of his tenderness is like a Minotaur gazing at a cow."

What can an art historian make of this? It is Picasso refracted through Davenport's inner geography, not an attempt at some ahistorical snapshot written as though it could be true forever. Instead, what we find in Davenport are the artists themselves, alive, full of vigor and idiosyncrasy, freed from the periods that we retroactively and often lazily group them under, and so free to stride and overstep those extrinsic bounds as they see fit.

Davenport introduces us to Henri Rousseau like this: "Until we are willing to enter Rousseau's world we are going to misread all his paintings. We must learn the tone of his sentimentality, his sense of humor, his idea of art."

If we enter Rousseau's world we can learn new tones of feeling, new humor, a different idea of art, and then read his paintings right. Along the way we'll see our own world differently. Davenport looks at art like a painter and speaks like one. He tells us that Rousseau and Flaubert saw the Canal Saint-Martin (in Paris) with the same eyes, around the same time, and makes us feel the significance of that fact. With him, we can consider how the stuffed parrot, Loulou, at the end of *A Simple Heart* might remind us of one of Rousseau's primitive beasts.

It's a different kind of history. It depends on filling in gaps, seeing how the collision of facts that are separated by time or space can become meaningful when we imagine their connective tissue: the possibility (not reality) of mutual influence.

Davenport is fascinated by the "primitive" in art. He insists that the artists we once called primitive are "true poets" because they "know no ordinariness," and he's right. Everything Bill Traylor saw later in life was poetically rich to him and real. It all had a right to be drawn or painted—every dog and pig and tree, every memory of an overseer on a plantation. He was self-taught, like Rousseau and Balthus, both of whom Davenport considers great primitives. There is magic in this kind of meaning-making, the kind that treats everything at face value as valuable and so elevates it.

Davenport is himself a primitive thinker in the sense that he trusts the wildness of the world and all its confluences, and the powers of the imagination and intuition, to lead him somewhere worth going. If Charles Dickens is a "primitive storyteller, trusting to genius to show him how his troupe of actors would interact," then Davenport is a primitive critic, trusting that a troupe of artists and thinkers, famous and little-known, will mix with his genius and create something new. And, in the end, like Dickens, he trusts "human nature, a primitive idol" to deliver him a world he can share with us.

"Balthus, I suspect, has been excluded from the clan [of modernism] for reasons of awesome primitiveness," he

writes. Davenport has been excluded from the clan of art history—and of contemporary criticism—for the same reasons. What he does with knowledge and information is what any great artist does with his or her medium—communicate a feeling first and then a whole world of thoughts, a nexus of possible realities attached to our own. His authority is an artist's authority or a child's, grounded in the conviction of the imagination to furnish a world. That may be why he liked Balthus so much:

> What caught Balthus's imagination in it was the manner in which children create a subsidiary world, an emotional island which they have the talent to *robinsoner*, to fill all the contours of. This subworld has its own time, its own weather, its own customs and morals.

What fascinated Balthus about the inner lives of children fascinated Davenport about Balthus. These private worlds rise up out of nowhere, created by artists or children, and we find them on our own or with the help of a guide. Davenport concerns himself with the imagination because the imagination doesn't impose itself, doesn't create rules or categories, but intermingles with the world and, in the end, brings it to blossom.

In the course of *A Balthus Notebook*, Davenport introduces us to more than 150 different people—from Anacreon to Wyndham Lewis, Ivan Puni to Eudora Welty—a whole village in a few thousand words. Roughly thirty

Guy Davenport's original citations are indicated here by his initials, in brackets, following the full publication information.

1    Meyer Schapiro, *Modern Art* (New York: George Braziller, 1978), p. 168. [GD] Full entry is a direct quotation.

2    Claude Lévi-Strauss, *The Elementary Structures of Kinship*, tr. James Harle Bell, John Richard von Sturmer, and Rodney Needham (Boston: Beacon Press, 1969), p. 4. [GD] Full entry is a direct quotation.

3    "God is the opposite of Rodin" is from Robert Walser's story "Market." See Robert Walser, *Berlin Stories*, tr. Susan Bernofsky (New York: New York Review Books, 2012).

5    Maurice Merleau-Ponty, *The Primacy of Perception*, ed. James M. Edie and tr. William Cobb (Evanston, IL: Northwestern University Press, 1964), p. 161. [GD] Full entry is a direct quotation.
     *"C'est effrayant, la vie"*: Translates to "Life is terrifying."

6    Balthus's *Mitsou: Quarante images par Baltusz, préface de Rainer Maria Rilke* was published in 1921 by Rotapfel-Verlag (Erlenbach-Zurich and Leipzig); Janusc Korczak's *Król Macius̆ Pierwszy* (*King Matt the First*) was first published in 1922 in Warsaw. [GD]
     *"for a Chinese novel"*: Sabine Rewald, *Balthus* (New York: The Metropolitan Museum of Art, 1984), p. 167. [GD]
     *drawings to illustrate* Wuthering Heights: Eight of these appeared in the surrealist magazine *Minotaure*, no. 7, 1935 and all of them are reproduced in Rewald, *Balthus*, pp. 161–166. [GD] Balthus created fourteen illustrations for Emily Brontë's *Wuthering Heights*.
     La femme 100 têtes: Commonly translated as *The Hundred Headless Woman*, *La femme 100 têtes* is Max Ernst's first collage novel; *Une semaine de bonté* is commonly translated as *A Week of Kindness*.
     *influence on Balthus of Hogarth*: Nicholas Fox Weber similarly notes the primary influence of William Hogarth, as well as that of Nicolas Poussin, Georges Seurat, Gustave Courbet, and Piero della Francesca, on Balthus's art. Nicholas Fox Weber, *Balthus: A Biography* (Champaign, IL: Dalkey Archive, 2013), pp. 17, 435.
     *cat dining on fish*: This work, from 1949, is titled *The Méditerranée's Cat*. *King of the Cats*: A self-portrait titled *The King of the Cats*, from 1935, which Balthus painted when he was twenty-seven years old.
     *"In 1922 … child forever"*: Rewald, *Balthus*, p. 11.

*Fourier's vision of a New Harmony*: See also entry ten, p. 31. Charles Fourier (1772–1837) was a French philosopher and an early advocate of utopian socialism.

*"was intent on . . . Marx and Fourier"*: Gary Smith, ed., *On Walter Benjamin: Critical Essays and Recollections* (Cambridge, MA: MIT Press, 1988), p. 368. [GD] Bracketed editorial insertion Davenport's own.

*Korczak led the procession . . . white field*: Betty Jean Lifton, *The King of Children: A Biography of Janusc Korczak* (New York: Farrar, Straus & Giroux, 1988), pp. 339–340. [GD] Korczak (1878–1942), a Jewish humanitarian and doctor, as well as a writer, ran an orphanage for Jewish children in the Warsaw ghetto during the Holocaust. He and the 192 children from the orphanage (what Davenport refers to as his "Republic of Children") were forced by the Gestapo to the Nazi death camp Treblinka in August 1942.

7   Colette, *Mitsou*, tr. Raymond Postgate, in *Six Novels by Colette* (New York: Modern Library, 1957), pp. 341–342. *Mitsou, ou Comment l'esprit vient aux filles* was first published in 1913 in Paris by Flammarion. [GD]

8   *The Golden Days*, 1944–1946.

10   *The Passage du Commerce Saint-André*, 1952–1954.
    *Proust's "little band" . . . Balbec*: Balbec is a fictional seaside resort in Normandy in Proust's *In Search of Lost Time*. The "little band" and the "Little Horde," in the next sentence, refer to the groups in which Fourier organized children. Saint-Loup refers to the fictional character Robert de Saint-Loup, in *In Search of Lost Time*.

12   *Sir Herbert Read*: "I do not deny the great accomplishment and permanent value of the work of such painters as Edward Hopper, Balthus, Christian Bérard, or Stanley Spencer (to make a random list); they certainly belong to the history of art in our time. But not to the history of the style of painting that is specifically 'modern.'" Sir Herbert Read, *A Concise History of Modern Painting* (New York: Frederick A. Praeger, 1959), pp. 7–8.

14   *Malraux has his theory*: See André Malraux, *The Twilight of the Absolute*, tr. Stuart Gilbert (New York: Pantheon Books, 1950).

16  *The Farmyard*, 1954; *The Dream*, 1955; *The Mountain*, 1936–1937. While Balthus does have a work titled *The Window*, from 1933, Davenport is most likely referring to the 1957 painting titled *Girl at the Window*. There are two versions of *The Living Room*, one from 1941–1943, now at the Minneapolis Institute of Arts, and the other from 1942, now at The Museum of Modern Art, New York.

    Rocks at Mouthier ... The Etretat Cliffs After the Storm: In the first edition of Davenport's book, these two titles appeared in the original French, *Les rochers de Mouthiers* and *La falaise d'Étretat après l'orage*.

17  *Nude with Cat and Mirror*, 1977–1980. This work is now also known as *Cat at the Mirror I*.

18  Alex Comfort, *Darwin and the Naked Lady: Discursive Essays on Biology and Art* (London: Routledge, 2013), p. 71.

19  *With the boards ... take from him*: Stephen Dobyns, *The Balthus Poems* (New York: Atheneum, 1982), p. 34. [GD]

21  Davenport is referring to Balthus's paintings *André Derain* (1936) and *Joan Miró and His Daughter Dolores* (1937–1938).

22  *The Vicomtesse de Noailles*, 1936.

23  *The Street*, 1933.

    *the Saltimbanques*: Refers to Pablo Picasso's 1905 painting *Les saltimbanques*. It is generally accepted that Rainer Maria Rilke's *Fifth Duino Elegy* was inspired by this painting. See also entry 30, p. 59.

    *according to Jean Leymarie*: Jean Leymarie, *Balthus* (Geneva: Skira, 1979), p. 61.

    *Waiting for Godot*: In the first edition of *A Balthus Notebook*, the title of Beckett's play appeared in the original French, *En attendant Godot*, likely as the play was written and first published in French.

25  *Blue and Rose periods*: Picasso's Blue period lasted from about 1901 to mid-1904, and the Rose period began in 1904, when Picasso moved to Montmartre.

28  *"Eins within a ... wohned a Mookse"*: This is the opening line of James Joyce's retelling of the Aesop fable "The Fox and the Grapes" in *Finnegans Wake* (London: Faber & Faber, 1939).

    *The Painter and His Model*, 1980–1981.

29  *"For now we see ... face to face"*: I Corinthians 13:12. [GD]
    *The white-clad carpenter ... arms like a puppet*: Leymarie, *Balthus*, p. 9. [GD]
    *on which menus are posted*: Rewald, *Balthus*, p. 60. [GD]

30  *return of Rilke's homage*: *The Children* now hangs in the Musée Picasso. [GD]
    *The Children*, 1937, is also known as *The Blanchard Children*.

31  *Under the guidance of instinct ... of liberation*: Eudora Welty, *Acrobats in a Park* (Northridge, CA: Lord John Press, 1980), p. iv. [GD]

33  *"bees of the invisible"*: This line comes from a letter Rilke wrote to Witold von Hulewicz, postmarked November 13, 1925. See *Letters of Rainer Maria Rilke: Volume 2, 1910–1926*, tr. Jane Bannard Greene and M. D. Herter Norton (New York: W. W. Norton, 1948), p. 374.

36  *The Greedy Child*, 1938; *Still Life with a Figure*, 1940; *The Living Room*, 1941–1943; *The Three Sisters*, 1954–1955; *The Triangular Field*, 1955; *The Golden Fruit*, 1956; *The Turkish Room*, 1965–1966; *The Room*, 1952–1954.
    *"signifies the revelation ... space"*: Rewald, *Balthus*, p. 100. [GD]

37  *"The great Surrealists ... Picasso, Bacon, Balthus"*: Marco Livingstone, *R. B. Kitaj* (New York: Rizzoli, 1985), p. 42. [GD]

38  Elémire Zolla, *Archetypes* (London: George Allen & Unwin, 1981), p. 16. [GD] Full entry is a direct quotation.

39  *"Many times, when ... bravado rather than truth"*: Charles Baudelaire, *The Salon of 1846*, in *The Mirror of Art: Critical Studies*, tr. and ed. Jonathan Mayne (New York: Phaidon, 1955), p. 71. [GD] Bracketed editorial insertion Davenport's own.
    *Le Départ pour l'île de Cythère* is a 1717 painting by Jean-Antoine Watteau, now commonly known as *The Pilgrimage to Cythera*.

40  *"the fabled theme ... eye of the beholder"*: Stanislas Klossowski de Rola, *Balthus* (New York: Harper & Row, 1983), p. 9. [GD]
    *Young Girl at a Window*, 1955.

41 Ethik und Aesthetik sind Eins: Translates to "ethics and aesthetics are one." Ludwig Wittgenstein, *Tractatus Logico-Philosophicus*, tr. C. K. Ogden (London: Kegan Paul, 1922), 6.421. The full text under entry 6.421 reads, "It is clear that ethics cannot be expressed. Ethics are transcendental. (Ethics and aesthitics are one.)"
   *Lascaux horse*: Refers to the Paleolithic paintings, primarily of large animals, in a complex of caves in Lascaux, in southwestern France.

42 *Theocritus VII*: Refers to Theocritus's *Idyll VII*. The Greek bucolic poet flourished in the third century BC. In Greek mythology, Eros is the god of love. Philinus refers to Philinus of Cos, a sprinter who won five Olympic victories.
   *Castor and Pollux*: In Greek mythology, Castor and Pollux are twin half-brothers, known as the Dioskouroi. Their mother is Leda, and in some versions of the myth, they are said to have been born from an egg, along with their sisters Helen of Troy and Clytemnestra.
   *the* it *of the subconscious*: Davenport here refers to the *id*, which is Latin for "it."
   347 Suite: In 1968, Picasso released a series of 347 engravings he completed in seven months. In the first edition of *A Balthus Notebook*, Davenport referenced this work by its French title, *347 Gravures*.

49 *"The history of contemporary painting . . . study and reflection"*: Claude Lévi-Strauss, *The View from Afar*, tr. Joachim Neugroschel and Phoebe Hoss (New York: Basic Books, 1985), p. 256. [GD]
   *"Hell is other people"*: From Jean-Paul Sartre's one-act philosophical play *No Exit* (*Huis clos*, in the original French), first performed in 1944 and first published 1945.

56 *"Light is time thinking about itself"*: The English translation is from Octavio Paz, *A Tree Within*, tr. Eliot Weinberger (New York: New Directions, 1988), p. 95. [GD]

58 *I said no more . . . bared crotch*: This is Davenport's own translation, previously published in "Archilochos: Epode; Fireworks on the Grass," *The Hudson Review* 28, vol. 3 (Autumn 1975), p. 353. The original Greek text was composed around 650 BC.
   *And now she moves . . . heavy heart*: This is Davenport's own translation, first published in *Sappho: Poems and Fragments* (Ann Arbor: University of Michigan Press, 1965), p. 22. The original Greek text was composed between the seventh and sixth centuries BC.
   *The Toilette*, 1957; *The Cup of Coffee*, 1959–1960; *The Three Sisters*, 1965; *Sleeping Nude*, 1980.

61  Pierre, baron de Coubertin, is considered the founder of the modern Olympic Games, which were revived in 1896.

62  *"When he was nineteen... he could see"*: Gertrude Stein, *Picasso* (London: B. T. Batsford, 1938), p. 1. [GD]

63  *Federico Fellini, writing... heritage in painting*: Jean Leymarie and Federico Fellini, *Balthus* (Venice: Edizioni La Biennale, 1980), p. 17. [GD]

64  *La Grande Jatte*: Georges Seurat's 1884/1886 painting *A Sunday on La Grande Jatte—1884*.

BALTHUS (1908–2001) was born Balthasar Klossowski in Paris to an artistic Polish family. As an artist who rejected the trends of avant-gardism, he created a singular style within the traditional painting categories of the landscape, the still life, and the portrait. He is best known for his depictions of adolescent girls, making his work the subject of continued interest and contention. At Balthus's first solo exhibition at Paris's Galerie Pierre, in 1934, his paintings' eroticism compelled a critic to name him "the Freud of painting." Other critics have considered the artist's work as truthful representations of the awkwardness, freedom, and innocence of youth. Balthus's contemplative, dreamlike scenes draw on Italian Renaissance precedents, particularly the work of Piero della Francesca, French classicism, and Gustave Courbet's realism, among other influences. The poet Rainer Maria Rilke was a champion of the young Balthus, and the artist's circle later included the dramatist Antonin Artaud—for whom he designed costumes and sets—the symbolist Maurice Denis, and the film director Federico Fellini. In 1961, Balthus was appointed director of the French Academy in Rome, a position he held for fifteen years. Balthus's legacy continues to be probed through major exhibitions of his work.

GUY DAVENPORT (1927–2005) was born in Anderson, South Carolina, and was educated at Duke, Harvard, and Merton College, Oxford. He was a recipient of a MacArthur Fellowship and the Morton Dauwen Zabel Award from the American Academy of Arts and Letters, and he was a finalist for the National Book Critics Circle Award. The author of more than forty books of fiction, essays, poetry, and translations, he was also a visual artist who frequently illustrated his own work. A selection of work from the American polymath can be found in *The Guy Davenport Reader* (2013).

JUDITH THURMAN began contributing to *The New Yorker* in 1987 and became a staff writer in 2000. She writes about books, culture, and fashion. Her story on Yves Saint Laurent was chosen for *The Best American Essays 2003*. "First Impressions," her 2008 reportage about the world's oldest art—the Paleolithic paintings at the Chauvet Cave, in southern France—was the inspiration for Werner Herzog's film *Cave of Forgotten Dreams*. She is the author of *Isak Dinesen: The Life of a Storyteller*, which won the 1983 National Book Award for nonfiction, and *Secrets of the Flesh: A Life of Colette*, the winner of the Los Angeles Times Book Prize for Biography and the Salon Book Award for biography. The Dinesen biography served as the basis for Sydney Pollack's movie *Out of Africa*. A collection of her *New Yorker* essays, *Cleopatra's Nose: 39 Varieties of Desire*, was published in 2007. She received the Rungstedlund Prize and the Harold D. Vursell Memorial Award for prose style, from the American Academy of Arts and Letters.

"Ekphrasis" is traditionally defined as the literary representation of a work of visual art. One of the oldest forms of writing, it originated in ancient Greece, where it referred to the practice and skill of presenting artworks through vivid, highly detailed accounts. Today, "ekphrasis" is more openly interpreted as one art form, whether it be writing, visual art, music, or film, that is used to define and describe another art form, in order to bring to an audience the experiential and visceral impact of the subject.

The *ekphrasis* series from David Zwirner Books is dedicated to publishing rare, out-of-print, and newly commissioned texts as accessible paperback volumes. It is part of David Zwirner Books's ongoing effort to publish new and surprising pieces of writing on visual culture.

## OTHER TITLES IN THE *EKPHRASIS* SERIES

*A Balthus Notebook*
Guy Davenport

Published by
David Zwirner Books
529 West 20th Street, 2nd Floor
New York, New York 10011
+ 1 212 727 2070
davidzwirnerbooks.com

Managing Director: Doro Globus
Editorial Director: Lucas Zwirner
Sales and Distribution Manager:
Molly Stein

Project Editor: Elizabeth Gordon
Project Assistant: Katherine Adams
Proofreader: Michael Ferut

Design: Michael Dyer / Remake
Production Manager: Jules Thomson
Production Coordinator:
Claire Bidwell
Production Assistant:
Elizabeth Koehler
Printing: VeronaLibri, Verona

Typeface: Arnhem
Paper: Holmen Book Cream,
80 gsm

*A Balthus Notebook* was first
published, in 1989, by Ecco Press,
New York.

"Free Associations" was originally
published as "My Visit with Balthus"
by *The New Yorker* online, September
27, 2013. The author has edited and
expanded the text for this volume.

A version of "On Davenport
(Who Also Wrote Well About Art)"
was published by *The Paris Review*
online.

Distributed in the United States
and Canada by
Simon & Schuster, Inc.
1230 Avenue of the Americas
New York, New York 10020
simonandschuster.com

Distributed outside the
United States and Canada by
Thames & Hudson, Ltd.
181A High Holborn
London WC1V 7QX
thamesandhudson.com

ISBN 978-1-64423-032-9

Library of Congress
Control Number: 2020901902